THE IMPRESSIONISTS'

PARIS

WALKING TOURS OF THE PAINTERS' STUDIOS,
HOMES, AND THE SITES THEY PAINTED

BY ELLEN WILLIAMS

THE LITTLE BOOKROOM
NEW YORK

Cover design: Louise Fili Ltd
Book design: Angela Hederman
Graphic Design: Mimi Taufer, Métier

Cover: Gustave Caillebotte, *Paris Street: Rainy Day,* 1877, oil on canvas, 212.2 x 276.2 cm,
Charles H. and Mary F. S. Worcester Collection, 1964.336 photograph © 1966 The Art Institute of Chicago.
Cover map: *Excursions dans Paris sans voitures,* 1867

The Little Bookroom acknowledges with appreciation the contributions of Katharine Berkman,
Edward Colquhoun, Arnulf Conradi, Mariella De Spigna, Margarette Devlin, Betsy Ennis, Monica Fraile,
Lorraine Glennon, Eliza Moore, Barbara Nagelsmith, Roslyn Schloss, Diane Seltzer, Paul Ukena.

Manufactured in China by South China Printing Company Ltd.
First Printing September 1997
10 9 8 7 6 5

Library of Congress Cataloging-in-Publication Data
Williams, Ellen. The impressionists' Paris : walking tours of the painters' studios, homes, and the sites they painted / by Ellen Williams.
p. cm. ISBN 0-9641262-2-2 1. Impressionist artists–Homes and haunts–France–Paris–Guidebooks. 2. Artists' studios–France–
Paris–Guidebooks. 3. Paris (France)–In art. 4. Paris (France)–Guidebooks. I. Title. ND550 .W55 2002 759.4361–dc21 2002152520

Published by The Little Bookroom
1755 Broadway, New York NY 10019
(212) 293-1643 Fax (212) 333-5374
editorial@littlebookroom.com

To Lars Berkman

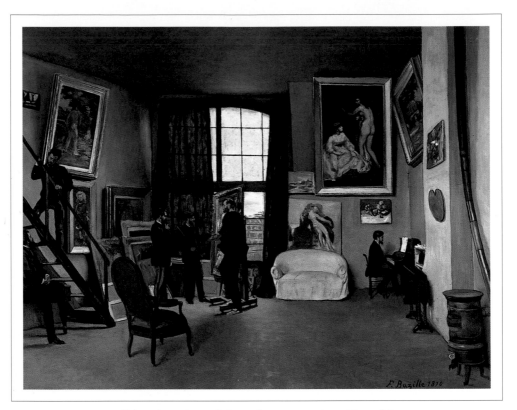

Bazille: *Studio in the rue de la Condamine,* 1870. Paris, Musée d'Orsay

Contents

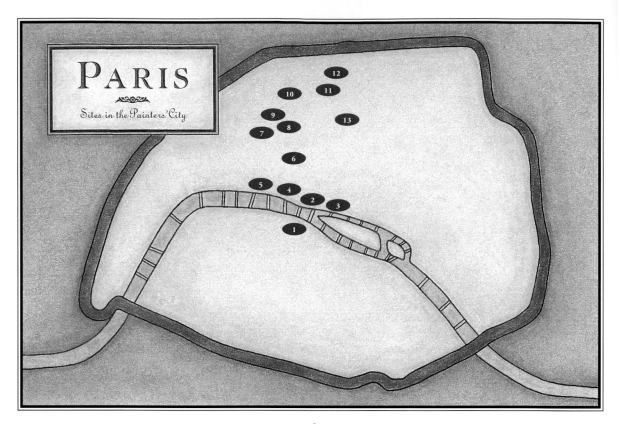

This book introduces you to the Paris of the French Impressionist painters, a Paris still vivid on museum walls but easily missed on the streets of the city today if you don't know where to look.

On these walking tours you will visit not only the places the artists chose to paint but also the studios in which they worked, the buildings where they lived, and – this being Paris – the cafés in which they gathered.

Given the size of the city, these walks are remarkably manageable. The sites (indicated by blue ovals) are not only close to one another, and arranged to be visited in roughly chronological order, but also near places of interest to lovers of Impressionism. The tour of the earlier paintings begins on the edge of the Left Bank near the Musée d'Orsay, whose collection includes several paintings discussed in the book; the walk of the later cityscapes is on the Right Bank, through the environs of the Gare Saint-Lazare and could be combined with a departure from that station for Monet's home in Giverny. The third walk is to the sites of the Impressionist haunts – the cafés, dance halls, and cabarets. At each stop, look to the left-hand scrapbook pages for related topographical and historical notes, anecdotes about the painters and paintings, important addresses (green dots), and recommendations for conveniently located cafés, *patisseries*, and restaurants – many dating from the

Caillebotte: *Paris Street; Rainy Day* (detail); Monet: *The Pont Neuf* (detail).

Impressionist era (red dots). These can all be located on the appropriate map, where additional sites mentioned in the text are indicated by black dots. Throughout the book, vintage postcards provide a photographic record of the sites as they existed when the painters selected them as subjects for their paintings.

Despite the relatively small territory covered on the walks, they will show you four distinct "faces" of the city: the historic Paris along the Seine, the bustling commercial Paris of the *grands boulevards*, Baron Haussmann's bourgeois Paris in the quartier de l'Europe, and the rustic, bohemian Paris of Montmartre.

The paintings reproduced here introduce the stylistic and thematic ties that unite these artists as well as reflect the differences that separate them: Manet and Monet both created works of the city's Gare Saint-Lazare, but one shows no trains, the other no people; Caillebotte and Monet both painted pedestrians crossing through the rain-slicked streets of Paris, one in detailed sharp focus, the other with shorthand dashes of pigment; Renoir and Degas both depicted Parisians imbibing, one revelers in the sunshine, the other alcoholics in the cold light of the morning after.

This book brings the museum experience out into the real world, to better appreciate both the art and the city, one through the other. The paintings are your guides to the Paris of the Impressionists, long gone but still visible to those who stop to look.

ÉDOUARD MANET

EDGAR DEGAS

CLAUDE MONET

1832-1883

1834-1917

1840-1926

INTRODUCTION

No style of painting conjures up the charm and grace of 19th-century Paris more than Impressionism. We can instantly call to mind those colorful views of stylish Parisians relaxing in smoke-filled cafés and cabarets or strolling along the city's bustling *quais*, bridges, and boulevards. Yet, for all the scenes of the Tuileries gardens, the Bois de Boulogne, and suburban boating parties along the Seine, the Impressionists represented the actual streets of Paris relatively rarely — mainly during the late 1860s through the 1870s and, perhaps most surprisingly, within a fairly limited area of the city. Among hundreds of Impressionist canvases, there are only a small number that depict recognizable Parisian landmarks by Manet, Monet, and Renoir, and only one — a view of the place de la Concorde — by Degas. With few exceptions, these artists set up their easels in just two areas — along the banks of the Seine near the Louvre or in the area around the Gare Saint-Lazare in the 8th arrondissement — all but ignoring the entire half of the city on the Left Bank. There are no views of Notre Dame or the Arc de Triomphe, and when monuments do appear, they tend to be seen from a distance, symbols of the nation's history rather than precise records of particular places in the city.

Nonetheless, these Paris views tell us a great deal about the Impressionists as individuals and as a group. They were initially drawn together in the common belief that painting must be of

PIERRE-AUGUSTE RENOIR

1841-1919

FRÉDÉRIC BAZILLE

1841-1870

GUSTAVE CAILLEBOTTE

1848-1894

its own time and that the art endorsed by the establishment was pompous and outdated, though it was the hostile reaction to their bold new style – now universally beloved, but in its day considered radical and subversive – that really united these artists. However, they were also quite different in their backgrounds, temperaments and artistic aims. Manet was most interested in representing people, Degas in line and form, Monet in the play of light, Renoir in the joy of life. Some painted in the open air, others in the studio. Among them were wealthy Parisians and middle-class provincials. But despite their differences, then as now, they have always been seen as a group.

They were known as the *bande à Manet* or the Batignolles Group, after the area of town in which their notorious leader resided, kept studios, and gathered with friends at cafés. In this global age, it is difficult to imagine how small a world these artists inhabited in the Batignolles and neighboring districts, such as the quartier de l'Europe, Pigalle, and Montmartre. Monet was born a block from Degas, who died eight decades later in a house less than a half mile from there. Manet, though born on the Left Bank, spent most of his life in a series of apartments and *ateliers* a short stroll from the place de Clichy. These artists were major figures in one another's lives. Bazille was godfather to Monet's son, Renoir the executor of Caillebotte's estate. They posed for one another, collected one another's work when no one else would, paid one another's rent when times were tough.

Paris in the first half of the 19th century was a very different city from the one the Impressionists would paint in the 1860s and 1870s. In an age of recurring political instability, it was still largely a medieval city, unsanitary and almost impossible to police. When Napoleon III came to power in 1851, he was quick to realize that in order to maintain his rule, the city would have to undergo a wholesale modernization. The emperor turned to his chief urban planner, Baron Georges Haussmann, a man whose name has become synonymous with the mammoth renovation that more or less created the Paris we know today. Narrow, winding alleys were replaced by broad, straight boulevards, entire working-class neighborhoods cleared to make way for new residential, commercial, and cultural districts for the upper bourgeoisie. Under Haussmann nearly 30,000 houses were demolished, replaced with more than 100,000 new ones – complete with indoor plumbing, sewage and gas lines, and all conforming to his strict design regulations. More than 30,000 gas lamps replaced 15,000 lanterns. His plans doubled the number of trees that lined the streets and added acres of parkland. New bridges spanned the Seine; train stations were enlarged and modernized. The city was to be healthier, easier to control, shining, beautiful, the envy of the civilized world.

With much of the capital dug up for years, the transformation of Paris affected everyone.

While builders and speculators profited immensely, many Parisians mourned the loss of much of the city's heart and soul. Victor Hugo likened the new boulevards to stab wounds that had pierced a body in a sword fight. Other critics wondered if Baron Haussmann would attempt to straighten out the curve in the Seine. Everyone, it seemed, had an opinion. Pro or con, the Impressionist painters were intrigued, making their new and modern city a central theme of their new and modern art.

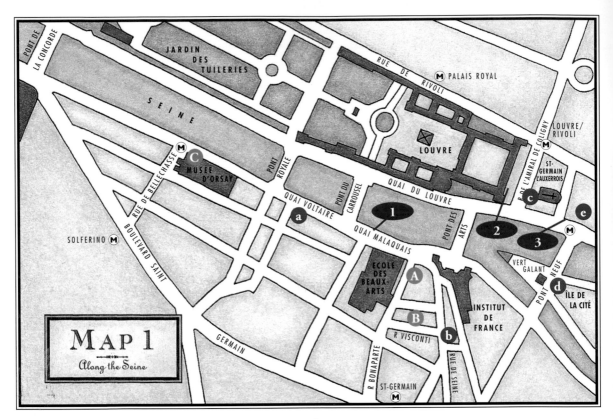

PONT DE LA CONCORDE

JARDIN DES TUILERIES

SEINE

Ⓜ PALAIS ROYAL

RUE DE RIVOLI

LOUVRE

Ⓜ LOUVRE/ RIVOLI

R. DE L'AMIRAL DE COLIGNY

ST-GERMAIN L'AUXERROIS

Ⓜ BELLECHASSE

Ⓒ MUSÉE D'ORSAY

RUE DE BELLECHASSE

PONT ROYALE

QUAI VOLTAIRE

PONT DU CARROUSEL

QUAI DU LOUVRE

ⓒ

Ⓜ SOLFERINO

BOULEVARD SAINT

ⓐ

QUAI MALAQUAIS

❶

PONT DES ARTS

❷

ⓔ

❸

Ⓜ

VERT GALANT

PONT NEUF

ECOLE DES BEAUX-ARTS

Ⓐ

Ⓑ

R VISCONTI

ⓑ

INSTITUT DE FRANCE

ⓓ ÎLE DE LA CITÉ

GERMAIN

R BONAPARTE

RUE DE SEINE

MAP 1

Along the Seine

ST-GERMAIN Ⓜ

LEGEND

STOP 1 Quai Malaquais between rue Bonaparte and rue des Saint-Pères

STOP 2 Quai du Louvre and rue de l'Amiral de Coligny

STOP 3 Pont Neuf

A Birthplace of Édouard Manet - 5, rue Bonaparte

B Studio of Frédéric Bazille - 20, rue Visconti

C Musée d'Orsay - 1, rue de Bellechasse

a Restaurant Le Voltaire - 27, quai Voltaire **b** Café La Palette - 43, rue de Seine

c Maison Cador - 2, rue de l'Amiral de Coligny **d** Taverne Henri IV - 13, place du Pont Neuf

e La Samaritaine - 2, quai du Louvre

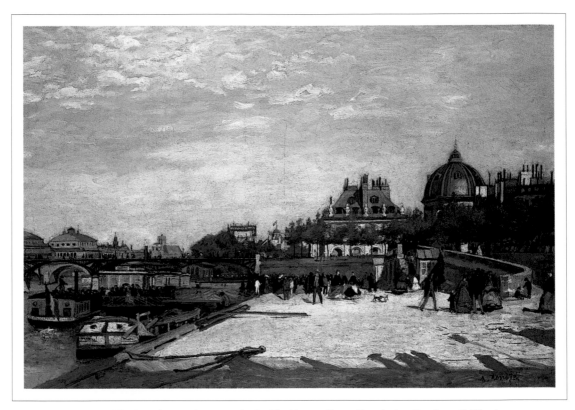

Renoir: *The Pont des Arts, Paris,* c.1867-68. The Norton Simon Foundation, Pasadena, California

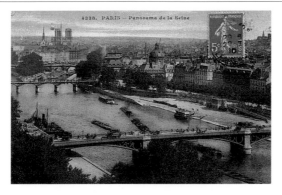

4338. PARIS – Panorama de la Seine

WALK 1: ALONG THE SEINE

STOP 1 **Quai Malaquais between rue Bonaparte and rue des Saint-Pères, site of Renoir's *Pont des Arts*, 1867. MÉTRO: Musée d'Orsay or Saint-Germain**

We start our tour on the quai Malaquais, at the site of one of the earliest Impressionist pictures of the city. Standing on the river side of the street, just beyond the pont du Carrousel and facing east, you can see the view taken down by Pierre-Auguste Renoir in 1867 in *The Pont des Arts*. By the mid-1860s, the young painters who would soon be known as the Impressionists had faced

Ⓐ BIRTHPLACE
OF ÉDOUARD MANET,
JANUARY 23, 1832
5, RUE BONAPARTE

Manet, the intellectual leader of the Impressionist circle, who habitually incited the contempt of the critics and public alike, undoubtedly recognized the irony that this, his first Parisian residence,

was neatly sandwiched between the two institutions that all but controlled the arts in 19th-century France: the École des Beaux-Arts across the street and the Académie des Beaux-Arts, which was housed in the Institut de France at the corner. The street was called rue des Petits Augustins until 1852, when Napoleon III renamed it in honor of his illustrious uncle.

Bazille: *The Artist's Studio, Rue Visconti, Paris,* 1867.
Virginia Museum of Art, Richmond

Ⓑ STUDIO OF
FRÉDÉRIC BAZILLE
20, RUE VISCONTI

In 1867 the well-to-do Bazille invited his financially strapped friends Auguste Renoir and Claude Monet to share his *atelier* around the corner from the École des Beaux-Arts. The boarders had only to walk two blocks to the Seine to paint their first Parisian cityscapes. Both Renoir's portrait of his host and Bazille's likeness of his guest – each painted in the rue Visconti studio that year – are now reunited on the walls of the Musée d'Orsay.

nearly universal scorn for their work. They suffered repeated rejection from the annual state-sponsored Salon, and when they were able to exhibit, their works were usually greeted with ridicule. As individuals they responded to this hostility differently. Manet was the most determined to gain acceptance at the Salon and chose not to join his comrades in any of their eight independent exhibitions. But Manet was one of the wealthier rebels. Like Degas, Bazille, and Caillebotte, he enjoyed a considerable income. Renoir, the son of a tailor, was among the poorest. His defiance of the narrow-minded establishment, like that of Monet, whose father was a grocer, was more than a matter of principle. Conforming to the Salon's standards would have meant sales and future commissions. Therefore, it may be no accident that in positioning himself to paint this work, Renoir literally turned his back on the Salon – housed in the Palais de l'Industrie, located where the Grand Palais now stands, a short distance down the river on the opposite bank.

In this seemingly straightforward picture of the small iron footbridge that connects the Louvre with the Institut de France, Renoir also created a visual metaphor for the opposition of the old and new parts of the city that was a topic of lively debate among all Parisians at the time. He frames his picture of the *pont* – constructed in 1803 by Napoleon I and named for the artworks housed in the Louvre – between the gleaming twin theaters that had just been erected on the place du Châtelet and the august 17th-century Institut, bridging in effect the city's history with his artwork.

ⓒ Musée d'Orsay
1, rue de Bellechasse
01.40.49.48.14
Jun 20-Sept 20: Tu, Wed, Fri-Sun
9am-6pm, Th 9am-9:45pm;
Sept 21-Jun 19: Tu-Sat 10am-6pm,
Th 10am-9:45pm, Sun 9am-6pm
(Closed Mon)
Métro: Musée d'Orsay/Solférino

956 PARIS. - La Gare du Quai d'C

Housed in a former train station built in 1900, the museum's collection picks up in 1848 where the Louvre's leaves off. Impressionist art is now enshrined here, just a short distance from the site of the old Salon, where these works were first met with such contempt. The heart of the Impressionist collection is the bequest of 38 works left to the state by the painter and patron Gustave Caillebotte in 1894 (short-sighted museum officials turned down another 27). Works from the tour that can be seen here include: Monet's *Gare Saint-Lazare*, Degas' *Absinthe*, Bazille's *Studio in the rue de la Condamine*, and Renoir's *Dancing at the Moulin de la Galette*. Note: Impressionist paintings are divided into pre-1870 on the first floor and post-1870 on the top floor.

ⓐ Le Voltaire
27, quai Voltaire
01.42.61.17.49
8am-2am
(Closed Sun and Mon)
Métro: Musée d'Orsay/Bac

A favored spot
of employees from the
nearby Musée d'Orsay.

ⓑ La Palette
43, rue de Seine
01.43.26.68.15 8am-2am
(closed Sun and Aug)
Métro: St.-Germain
This turn-of-the-century café and bar, decorated with old, paint-encrusted wooden palettes, has been a hang-out for generations of art students from the nearby École des Beaux-Arts.

LA PALETTE

Tél. 43.26.68.15 43, RUE DE SEINE
75006 PARIS

19th-century Parisians paid a sou, five centimes, to cross the Pont des Arts.

Renoir's figures stroll along the water's edge (the *quai* had recently been widened by Haussmann) and – visible only as shadows in the foreground – across the pont du Carrousel behind the painter. A sightseeing boat discharges and takes on passengers, a scene much like today (this is one of the stops of the so-called Batobus), although the access to the river embankment is now a flight of steps opposite the rue Bonaparte, replacing the stone ramp of Renoir's day.

The painter's financial hardships were not eased when *The Pont des Arts* fetched only seventy francs at an auction in 1875.

Cross the pont des Arts to the Right Bank and walk east along the quai du Louvre to the next corner, the rue de l'Amiral de Coligny.

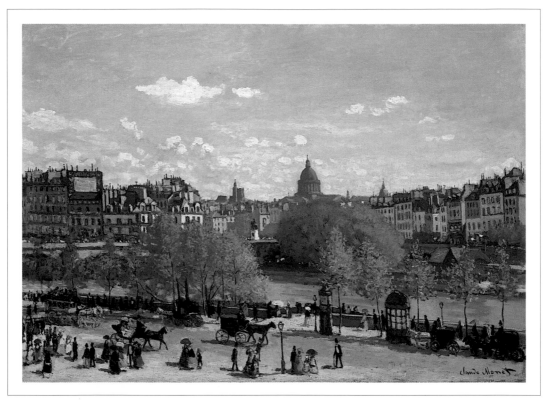

Monet: *Quai du Louvre*, 1867. The Hague, Gemeentemuseum

23. – PARIS. – La Colonnade du Louvre. – G. I.

STOP 2 **The corner of the quai du Louvre and the rue de l'Amiral de Coligny, below the balcony of the colonnade on the east facade of the museum, the site from which Monet painted three canvases in 1867**

Directly across the river from Renoir that same spring, the twenty-seven-year-old Claude Monet, like scores of other aspiring French artists, received permission to paint inside the Louvre museum. But unlike the others, Monet — a middle-class Parisian by birth who had returned to the capital in 1859 after having spent most of his childhood in the seaside town of Le Havre – had no interest in copying the works inside the galleries. As with his friend Renoir, his stance here

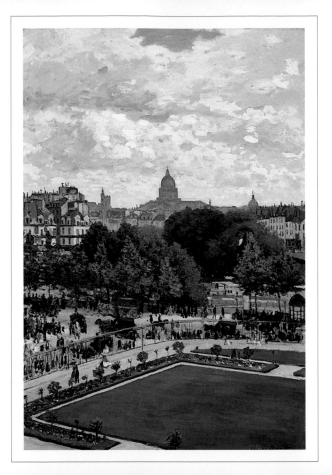

Monet: *Garden of the Princess, Louvre*, 1867. Allen Memorial Art Museum, Oberlin College, Oberlin, Ohio

is symbolic: he deliberately turned away from the Old Masters, preferring to set up his easel outside the galleries on the second-floor balcony of the museum to paint the city before him.

Inspired by the high vantage point of the Japanese prints he had just seen exhibited at the Paris World's Fair that year, Monet, too, venerates *vieux Paris* while celebrating Haussmann's modern city. In two of the three pictures he painted at this site – the horizontal *Quai du Louvre*, whose lighter-colored foliage means it was probably painted first, and the vertical-shaped *Garden of the Princess* – the artist looks out from the great storehouse of French culture across the city to the final resting place of the nation's most esteemed men, the then-century-old Panthéon, whose dome we see flanked between the tower of Saint-Étienne du Mont and the dome of the Sorbonne deep in the historic Latin Quarter. On the street beneath his perch, Monet's figures, like Renoir's, are out on foot and in horse-drawn carriages enjoying the wide new promenades along the river and beside the neatly manicured Princess Garden (Le Jardin de l'Infante).

Unlike truly native Parisians such as Édouard Manet, who aside from brief trips elsewhere rarely left the city, Monet made short visits to the capital between long stays in the country. Soon to move to the western suburb of Argenteuil, he confessed that Paris actually frightened him. In fact, with all the grand monuments in this dazzling city to choose from, Monet – here in 1867 and again

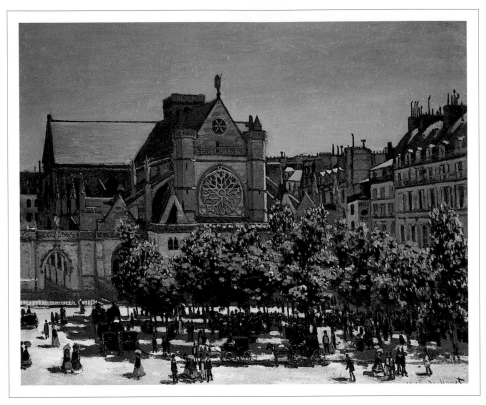

Monet: *Saint-Germain l'Auxerrois*, 1867. Berlin, Nationalgalerie

a few years later (Stop 3) – was drawn to the banks of the Seine, the river he would paint in its more leisurely rural incarnation over two hundred times during his long career.

The third work, this one completed from the center of the museum balcony – accessible from the galleries of ancient art at the top of the Escalier Égyptien – is *Saint-Germain l'Auxerrois,* a view of the Haussmann-restored Gothic church directly across the place du Louvre.

Though today it is one of the less famous among Paris' many religious buildings, it was significant for Monet, having been the parish church for the great French artists of the previous century who had been provided housing in the Louvre after the king moved to Versailles. As at the Panthéon, many such national luminaries were buried at Saint-Germain l'Auxerrois, including the painters Boucher and Chardin, as well as Soufflot, the architect of the Panthéon, and Le Vau, the designer of the Institut de France and the part of the Louvre from which Monet now worked.

With their bright, shimmering colors and feathery brush strokes, these paintings seem to echo the light and air that Baron Haussmann had introduced to the formerly dark and fetid city streets. But the gay mood of these early works by both Monet and Renoir completely belies the fact that this was a period of intense financial hardship for them, a difficulty that significantly increased for Monet when his mistress, Camille Doncieux, gave birth to a son a few months later. Monet

Organ recitals are held every Sunday at 5 p.m. at Saint-Germain l'Auxerrois. A special service for artists is held on Ash Wednesday.

c MAISON CADOR
2, RUE DE L'AMIRAL
DE COLIGNY
01.45.08.19.18
TU-SUN 9AM-7PM
MÉTRO: LOUVRE/RIVOLI
Maison Cador, an elegant little 19th-century *patisserie* and tea salon, stands just outside the right-hand frame of Monet's *Saint-Germain l'Auxerrois.*

Manet met both Degas and Berthe Morisot – whom he would paint 14 times and who would eventually marry his brother – in the Louvre in the 1860s. Manet and Monet first became aware of each other during the Salon of 1865, when the similarities of their names caused confusion among reviewers, with Manet being mistakenly praised for a seascape by Monet.

named Bazille Jean's godfather, immediately making the first of many appeals for monetary assistance on the child's behalf.

In these initial cityscapes of Paris, Monet hoped to find an audience among the thousands of tourists then visiting the capital for the fair. He did achieve some notoriety – not all of it positive – with *Garden of the Princess*, which was bought by the owner of a paint shop and displayed in his window at the corner of the rue Lafayette and the rue Lafitte (a block away from Monet's birthplace, which used to stand at N° 45 of the same street) in the 9th arrondissement.

Walk another block east along the quai du Louvre to reach the pont Neuf.

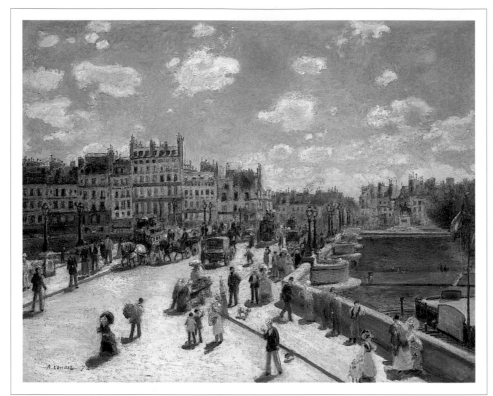

Renoir:
Pont Neuf, Paris
1872.
National
Gallery of Art,
Washington

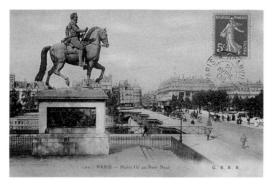

PARIS — Henri IV au Pont Neuf G. B. R. R.

STOP 3 Pont Neuf, site of paintings by Renoir and Monet, 1872

Despite its name, "New Bridge," the pont Neuf, which was completed in 1607 under Henri IV, is actually the oldest of the city's many spans across the Seine. The bridge crosses over the western tip of the Île de la Cité, the heart of medieval Paris and one of the historic areas most transformed by Haussmann's pickaxes, with more than ten thousand people there evicted from their homes. Both Renoir and Monet had included glimpses of the pont Neuf in the backgrounds of their 1867 riverbank pictures, and in 1872 they each returned separately to paint its Right Bank side from the second-floor window of a facing café. Renoir began his version in the spring.

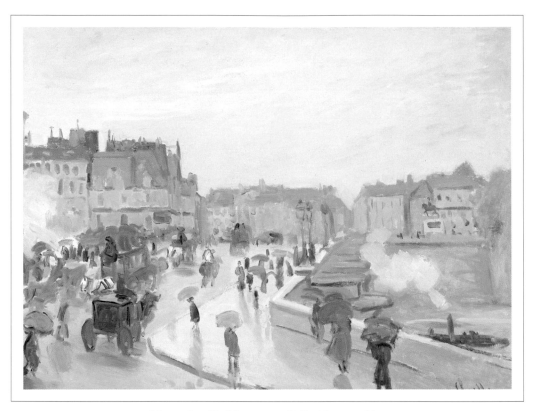

Monet: *Pont Neuf, Paris,* 1872. Dallas Museum of Art

His journalist brother Edmond, whose thumbnail-sized portrait is said to be included as one of the many pedestrians crossing through the scene, later recalled:

> We established ourselves on the mezzanine of a little café located on the corner of the quai du Louvre, which was closer to the Seine than the present-day buildings. For the price of a cup of coffee, ten centimes each, we could stay there for hours. Auguste overlooked the bridge and when he had painted the ground, the parapets, the buildings in the background, the place Dauphine, and the statue of Henri IV, he sketched the silhouettes of the passersby, the carriages, the little groups. I sat and wrote all this time, unless my brother asked me to go on to the bridge and speak to one of the people, asking them for the time or something to make them stand still.

The resulting work is another cheerful scene of fashionable Parisians idling in the sunshine, an activity that today would be impossible given the ceaseless rush of traffic across the bridge.

Monet, who now kept a *pied-a-terre* at 8, rue de l'Isly, a stone's throw from the Gare Saint-Lazare, had briefly returned to Paris, and inspired by his friend's example, undertook a view of the same setting the following fall, maintaining an almost identical vantage point but changing as much else as he could. Both artists looked across the bridge to the houses that line the banks

In painting the Pont Neuf, Renoir and Monet returned to the area they had each known well a decade earlier as art students. Renoir then lived on the triangular place Dauphine, opposite the bridge's midsection, while attending the nearby École des Beaux-Arts. Monet took classes at the inexpensive Académie Suisse, around the corner on the Île de la Cité's quai des Orfèvres.

TAVERNE HENRY IV
13, place du Pont-Neuf - 75001 PARIS
Réservation : 43 54 27 90

**ⓓ Taverne Henri IV
13, place du Pont-Neuf
01.43.54.27.90
Mon-Fri noon-10pm,
Sat noon-4pm
(closed Sun and Aug)
Métro: Pont Neuf**
Enjoy a snack at this relaxed wine bar that faces the equestrian statue of the Vert Galant.

The pont Neuf crosses the Seine at its widest point in Paris.

ⓔ La Samaritaine
quai du Louvre
01.40.41.29.29
Métro: Pont Neuf
Although the café from which Renoir and Monet painted is long gone, demolished around the turn of the century to make way for the Samaritaine department store, an overview of the site can be had either from the store's fifth-floor restaurant (Lunch: 11:45am-3pm, Tea: 3:30-6pm, Dinner: 7:30-11:30pm) or from the free rooftop observation deck (9:30am-8:30pm). Closed Sun.

of the Île de la Cité and the Left Bank beyond; both featured the equestrian statue of Henri IV, known as the Vert Galant (the Gay Blade), in the middle distance. But in Monet's more adventurous hands, Renoir's bright blue sky becomes overcast, parasols give way to umbrellas, a relaxed weekend is replaced by a hurried weekday, and a scene full of charming anecdote becomes an exercise in proto-abstractionist brushwork.

Walk back along the *quai* to the pont du Carrousel, turning right to enter the Jardin des Tuileries through the arches of the Louvre.

Or turn up the rue de l'Arbre Sec to the rue de Rivoli, taking the Métro, Line 1, from the Louvre/Rivoli station (Direction: La Défense) two stops to Tuileries (move to Map 2 on page 38).

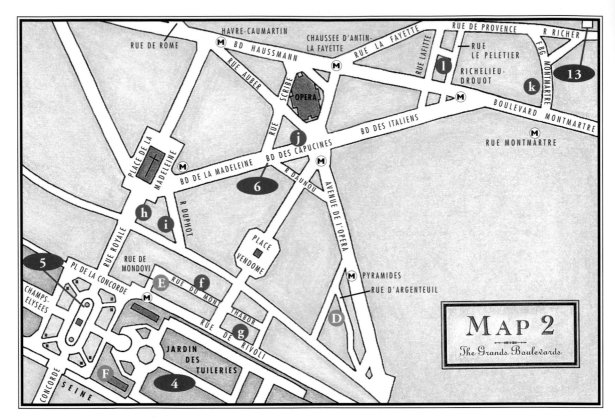

LEGEND

STOP 4 Jardin des Tuileries **STOP 5** Place de la Concorde

STOP 6 Boulevard des Capucines at rue Daunou

STOP 13 Folies-Bergère - 32, rue Richer

D Residence of Auguste Renoir - 23, rue d'Argenteuil

E Residence of Edgar Degas - 4, rue de Mondovi

F Musée de l'Orangerie - place de la Concorde

f Le Soufflé - 36, rue du Mont-Thabor **g** Angélina - 226, rue de Rivoli

h Ladurée - 16, rue Royale **i** Goumard Prunier - 9, rue Duphot

j Café de la Paix - 5, place de l'Opéra **k** Chartier - 7, rue du Faubourg-Montmartre

l Au Petit Riche - 25, rue Le Peletier

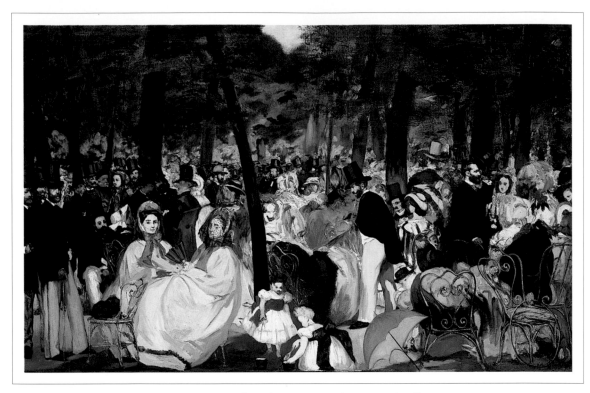

Manet: *Music in the Tuileries*, 1862. London, National Gallery

35. - PARIS. - Jardin des Tuileries

STOP 4 Jardin des Tuileries, site of Manet's *Music in the Tuileries*, 1862

I n the early 1860s, Édouard Manet, now residing on his own in the first of many addresses in the Batignolles district of town, returned almost daily to the kilometer-long Jardin des Tuileries, gardens he had lived near with his parents as a small boy on the rue des Petits-Augustins and then as a young man on the rue du Mont-Thabor. In the company of his good friend the writer Charles Baudelaire, the dapper artist would lunch at the chic restaurant Tortoni on the boulevard des Italiens before promenading and sketching in the park.

ⓓ RESIDENCE OF AUGUSTE RENOIR, 23, RUE D'ARGENTEUIL
Having settled in Paris from Limoges, where Renoir was born in 1841, the painter's family was forced to relocate to this address when Haussmann's extension of the rue de Rivoli demolished their first street. Auguste still lived here in 1860 when he applied for permission to copy at the nearby Louvre.

Paris. — Rue d...

RESTAURANT
Le Soufflé
(C. RIGAUD)
AIR CONDITIONNÉ

36, rue du Mont-Thabor
Toutes places Vendôme et Concorde)
75001 PARIS - Tél : 42.60.27.19
Fax : 42.60.54.98

ⓕ LE SOUFFLÉ
36, RUE DU MONT-THABOR 01.42.60.27.19
MON-SAT NOON-3PM, 7-10PM
MÉTRO: CONCORDE
Have a quintessential French dish on the street where the Manet family lived in the 1850s.

ⓖ ANGÉLINA
226, RUE DE RIVOLI
01.42.60.82.00
MON-FRI 9:30AM-7PM, SAT-SUN 8:30AM-7PM.
(CLOSED 3 WEEKS IN AUG.)
MÉTRO: TUILERIES.
This popular century-old tea salon faces the Tuileries gardens.

The 16th-century Palais des Tuileries, named for the tile works (tuileries) that once stood on the site, was the official royal residence from the early 19th century until it was torched during the Commune in May 1871. Its charred ruins remained a vivid reminder of the violence of that brief civil war until they were finally demolished in 1882. A fragment of the palace stands in the northwestern corner of the gardens behind the Jeu de Paume.

In the 1870s, Monet and Renoir would both paint the Tuileries Gardens from the 4th-floor apartment of an art collector at 198, rue de Rivoli.

During the summer of 1862, Manet, working in his studio, turned these drawings and watercolors done on the spot into one of the first major paintings of modern Parisian life, *Music in the Tuileries*. Under the broad canopy of leafy horse-chestnut trees, Manet presents a who's who of his own circle of well-to-do friends – fellow artists, musicians, and writers – assembled to see and be seen at one of the twice-weekly concerts given in the Tuileries palace gardens, which Napoleon III had recently opened to an appreciative public.

Manet begins his composition with a portrait of himself at the extreme left-hand edge, followed by that of his friend Albert de Balleroy, with whom he had shared his first *atelier* on the rue Lavoisier a short distance away. Next we see the seated poet Zacharie Astruc and the painter Henri Fantin-Latour, who looks out at us from beside a tree. Baudelaire, his features reduced to a simple profile, stands in front of that same tree. Manet's brother, Eugène, who would later marry the painter Berthe Morisot, is the gentleman with the white trousers. Behind him, in glasses, sits the composer Jacques Offenbach, whose *La vie parisienne* could be the anthem for the elegant, sparkling Second Empire society here gathered.

Continue westward through the gardens to the place de la Concorde.

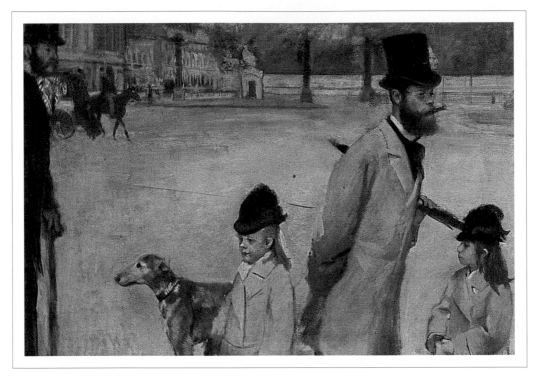

Degas: *Place de la Concorde*, c.1875. Formerly Gerstenberg/Scharf Collection, Berlin

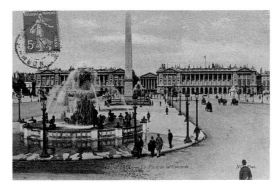

STOP 5 Place de la Concorde, site of Degas' work of the same name, c.1875. Stand on the north end of the center island facing the rue de Rivoli.

Edgar Degas lived with his widower father near the northeastern corner of the place de la Concorde at 4, rue de Mondovi (E) well into adulthood. Like Manet and Renoir, who also lived near the Louvre with their parents, the aristocratic young artist was listed among those allowed to copy the Old Masters there. The Degas family occupied a fourth-floor apartment, Edgar's studio an attic room that faced the *place*, the site in later years of what may be his only Parisian streetscape.

The work is essentially a portrait of his friend Viscount Ludovic Lepic, out for a stroll with his daughters, Eylau and Janine, and one of their prize hounds. For decades it was believed that *Place*

The Franco-Prussian War lasted from July 1870 to February 1871, with the French surrender leading to the exile of Napoleon III. Monet fled to England to avoid conscription. Renoir was drafted into the cavalry; Manet and Degas joined the National Guard. The most devastating loss for the Impressionists was the death in battle of Bazille shortly before his twenty-ninth birthday. The brief but bloody Commune, when Parisian rebels tried to overturn the new national government, lasted from March 18 to May 28, 1871, with thousands of civilians, mostly from the working class, killed in street fighting or executed without trial.

214. PARIS - La Statue de Strasbourg C. L. C.

The French vividly expressed the loss of Alsace by placing mourning wreaths around the statue of Strasbourg in the place de la Concorde (above). The city was returned to France after the German defeat in World War I.

h LADURÉE
16, RUE ROYALE
01.42.60.21.79. MON-SAT 8:30AM-7PM, SUN 10AM-7PM. MÉTRO: CONCORDE OR MADELEINE
Founded in 1862, this distinguished tea salon/*patisserie* is famous for its *croissants* and *macaroons*.

———

As he painted his one Paris cityscape, Degas had no way of knowing that many of his finest works would eventually be displayed in the Jeu de Paume, a 19th-century tennis court in the Tuileries, in the area to the left of Viscount Lepic's hat. These works are now on view in the Musée d'Orsay.

F MUSÉE DE L'ORANGERIE
PLACE DE LA CONCORDE
01.42.97.48.16
WED-MON 9:45AM-5PM
(CLOSED TU)
MÉTRO: CONCORDE
In celebration of the French victory in the First World War, Monet announced his intention to donate to the state a series of *nymphéas* (water lilies), installed in 1927, a year after his death.

de la Concorde, which had been in a private collection in Germany, was destroyed during World War II. Fortunately, it was recently discovered among works secretly removed to the Soviet Union. The painting's exact date is uncertain, though many scholars suggest 1875, and the work may in some way commemorate the centennial of its setting, called the place Louis XV at its inauguration in 1775. This monumental square – at twenty-one acres the largest in the city and ringed by statues personifying the eight great towns of France – had tremendous historical meaning for all French people as well as vivid personal associations for Degas himself.

It was renamed place de la Révolution in 1792, shortly before the infamous guillotine was erected near the entrance to the Tuileries (just to the right of Degas' picture), eventually taking more than 1,300 lives. In fact, Degas family legend claimed that the artist's grandfather here witnessed not only the execution of Queen Marie-Antoinette but also that of his own fiancée.

Rechristened Concorde in 1795, the *place* was again the locus of violence shortly before Degas painted it. During the civil uprisings that followed the Franco-Prussian War in 1871, insurgents erected barricades here – one at the foot of the rue de Rivoli (the area left of center in the background of the picture), another across the rue Royale (just beyond the painting's left edge). Degas makes subtle reference to the unhappy consequences of his nation's defeat by neatly obliterating behind Lepic's top hat the statue of Strasbourg, the Alsatian city just lost to Germany.

Walk up rue Royale, turning right onto the boulevard de la Madeleine, which becomes boulevard des Capucines, stopping at N°35.

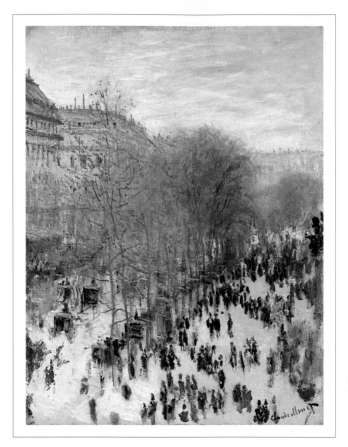

Monet:
Boulevard des Capucines,
1873-74.
Nelson-Atkins
Museum of Art,
Kansas City,
Missouri

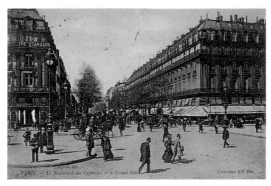

PARIS. — Le Boulevard des Capucines et le Grand Hôtel

STOP 6 N° 35, boulevard des Capucines, site of the first Impressionist exhibition and Monet's two paintings of the street, 1873-74

A year after depicting the pont Neuf, Monet painted the ultimate Haussmannian creation, the *grand boulevard*, setting the standard against which all future representations of these large Parisian thoroughfares would be judged. Again he worked from a balcony, this time at 35, boulevard des Capucines (at the corner of the rue Daunou), outside the vacated studio of the well known photographer Nadar, soon to be the site of the first of eight Impressionist exhibitions.

After years of rejection at the hands of the official Salon jury, a group of thirty artists, led

ⓘ GOUMARD PRUNIER
9, RUE DUPHOT
01.42.60.36.07
12:30-2:30PM, 7:30-10:30PM
(CLOSED SUN AND MON)
MÉTRO: CONCORDE
OR MADELEINE

Today an elegant seafood restaurant, Prunier was a simple oyster shop in the 1870s, the first in Paris to serve huîtres raw.

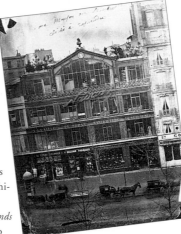

THE EIGHT IMPRESSIONIST EXHIBITIONS

Though they kept studios and frequented cafés in the backwater Batignolles district, the Impressionists chose the heart of commercial Paris for their independent exhibitions. Here along the fashionable, bustling *grands boulevards*, they hoped to attract wealthy buyers and dealers for their work.

If Degas had had his way, the Impressionists might be known today as the Capucines (Nasturtiums), which he suggested as the name for the group after the boulevard where the first exhibition would be held.

1874 - 35, boulevard des Capucines (above)
1876 - 11, rue Le Peletier
1877 - 6, rue Le Peletier
1879 - 28, avenue de l'Opéra
1880 - 10, rue des Pyramides
1881 - 35, boulevard des Capucines
1882 - 251, rue Saint-Honoré
1886 - 1, rue Lafitte

ⓙ CAFÉ DE LA PAIX
5, PLACE DE L'OPÉRA
01.40.07.32.32
10AM-1:30AM
(CLOSED AUG)
MÉTRO: OPÉRA

CAFÉ
de la
PAIX

Housed in the building shown at the left of Monet's *Boulevard des Capucines*, this historic café in the Grand Hotel was two years old when the Impressionists held their first exhibition across the street. Émile Zola, a great champion of the new artists, was a regular here.

by Monet and Degas, organized themselves into a syndicate that would show their works independently of the tightly controlled state-sponsored system. Monet wanted visitors to the exhibition to directly compare his vision of the teeming boulevard des Capucines with the real view outside the gallery windows. One hostile critic likened Monet's quickly dashing pedestrians to "black tongue lickings." Another, mocking the title of one of Monet's other entries, the seascape *Impression, Sunrise*, inadvertently gave the name "Impressionism" to the new movement.

The exhibition, though a financial as well as a critical fiasco, is now commemorated by a plaque that marks this art-historical landmark.

> Crossing the boulevard des Capucines, take the rue Scribe to the rue Auber, turning left. Continue to the boulevard Haussmann. Turn left. Head up the rue de Rome (move to Map 3 on page 52). Turn right onto the rue de Vienne and walk to the place de l'Europe.
>
> Or take the Métro, Line 3, from Opéra (Direction: Pont de Levallois) three stops to Europe.

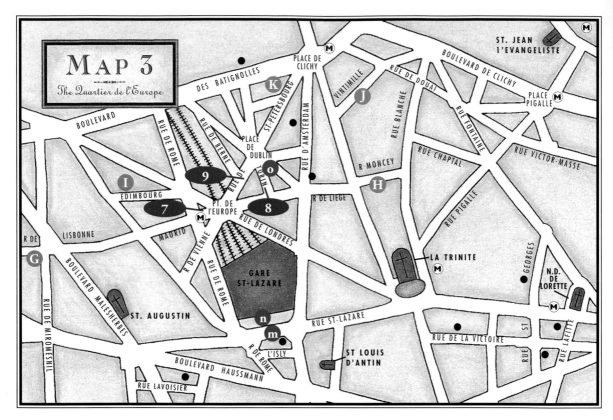

Legend

Stop 7 Place de l'Europe

Stop 8 Rue de Turin and place de Dublin

Stop 9 4, rue de Saint-Petersbourg

⊱⊶⊙⊷⊰

G Residence of Gustave Caillebotte - 77, rue de Miromesnil

H Studio of Claude Monet - 17, rue de Moncey

I Residence of Claude Monet - 26, rue d'Édimbourg

J Studio of Claude Monet - 20, rue Vintimille

K Final residence of Édouard Manet - 39, rue de Saint-Petersbourg

⊱⊷⊰

m Mollard - 115, rue Saint-Lazare **n** Café Terminus Lazare - 108, rue Saint-Lazare

o Le Primerose - 11 bis, rue de Moscou

⊱⊷⊰

● Additional Sites

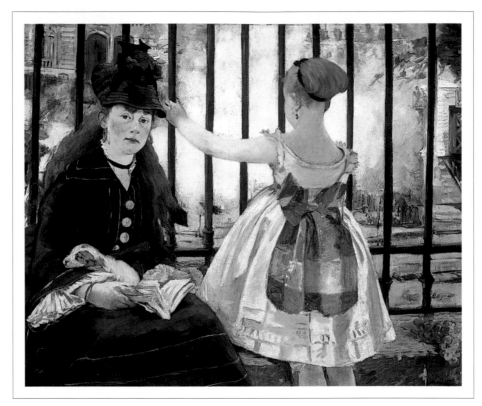

Manet: *Gare Saint-Lazare*, 1873. National Gallery of Art, Washington

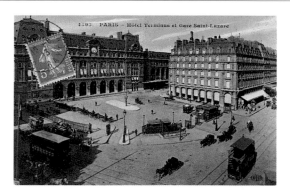

WALK 2: THE QUARTIER DE L'EUROPE

STOP 7 Place de l'Europe, site of works by Manet, Caillebotte, and Monet. Stand on the north side of the *place* looking toward the gardens behind the rue de Rome, site of Manet's *Gare Saint-Lazare*, 1873.

Though often considered the leader of the Impressionist circle, Manet declined repeated invitations to show with his friends at the first, or indeed any, of the eight exhibitions they organized. Determined to gain the recognition he believed was his due, he refused to give up on the

Manet in the Batignolles

Although he was born on the Left Bank, Édouard Manet spent most of his adult life in either the Batignolles district northwest of the Gare Saint-Lazare or in the adjoining quartier de l'Europe, one of Haussmann's new residential neighborhoods on the border between the 8th and 9th arrondissements.

Apartments

1860-63	rue des Batignolles
1864-66	34, boulevard des Batignolles
1867-78	49, rue de Saint-Petersbourg
1878-83	39, rue de Saint-Petersbourg. *After a long illness, Manet dies at this address at 7:00 p.m. on April 30, 1883* **K**

Studios

1850-56	rue de Laval (today rue Victor-Massé). *Attends art school of Thomas Couture*
1856-59	4, rue Lavoisier. *Manet leaves this* atelier *after the suicide there of his assistant.*
1859-60	58, rue de la Victoire
1860-61	rue de Douai
1861-70	81, rue Guyot (today rue Fortuny). *The building, which no longer stands, was severely damaged during the violence of the Commune. Fortunately, Manet had removed his paintings to a neighbor's cellar when the Prussians began the siege of Paris.*
1871-72	51, rue de Saint-Petersbourg
1872-78	4, rue de Saint-Petersbourg. *Manet paints the new rue Mosnier (today rue de Berne) from his second-floor studio window* (left; see Stop 9).
1878-79	70, rue d'Amsterdam
1879-83	77, rue d'Amsterdam. *Manet's last studio.*

Salon. As the others prepared the show, Manet began a painting of the Gare Saint-Lazare that would herald a series of works by other members of the Impressionist group of the quartier de l'Europe.

The station, which also figures in the work of the writers Émile Zola and Marcel Proust, had recently been rebuilt and the surrounding area cleared of slums to create a new upper-middle-class neighborhood whose streets were named for the great European cities and whose hub was the pont de l'Europe, an elevated six-street intersection poised above the busy rail yard.

Manet's *Gare Saint-Lazare* is not a cityscape or a portrait. We are not told who the figures are or what their relationship is to one another. It is simply a modern urban scene. A little girl stands before an imposing black-iron fence intently watching trains – rendered only by trails of puffy white steam – coming and going from the unseen station. Seated beside her in a stylish blue suit is her mother or governess, whom the viewer seems to have interrupted in her reading. The child was the daughter of the artist's friend Alphonse Hirsch, whose garden at 58, rue de Rome overlooked the tracks and may be the setting for the picture. The woman was Victorine Meurent, posing for the last time for Manet a decade after her nude appearances in his most notorious works, *Olympia* and *Déjeuner sur l'herbe* (both in the Musée d'Orsay), which, still unsold, hung on the walls of his studio, a block from the place de l'Europe, at 4, rue de Saint-Petersbourg (Stop 9).

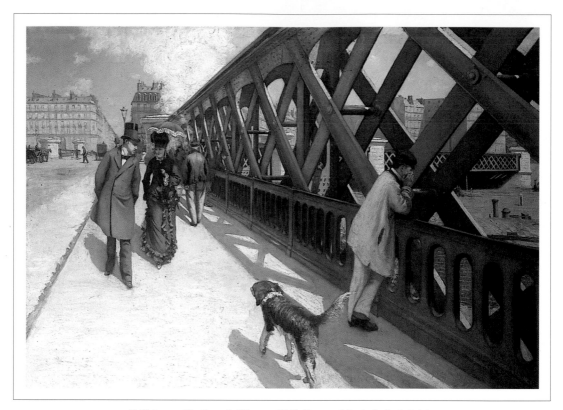

Caillebotte: *The Pont de l'Europe*, 1876. Geneva, Musée du Petit Palais

**Return to the rue de Vienne, stopping on the station side of the street, and
turn to face the *place*, site of Caillebotte's *Pont de l'Europe,* 1876.**

Visible at the far right of Manet's *Gare Saint-Lazare* is one of the massive stone pillars of the pont de l'Europe, one of the great engineering feats of Haussmann's new Paris, a setting that in the next few years drew another wealthy artist-resident of the neighborhood, Gustave Caillebotte. For decades, Caillebotte was remembered, if at all, as a friend and patron of the Impressionists, whom he often supported financially and whose works he was among the first to collect. In the last twenty years, however, his own work has been reappraised and his stature as an important figure in his own right confirmed.

In 1876 Caillebotte, who lived nearby in his family's mansion at 77, rue de Miromesnil at the corner of the rue de Lisbonne (G), completed two views of the *pont*, immediately affirming his affinity with the Impressionists, as well as establishing his own distinct artistic voice. For he, too, was interested in the huge metamorphosis of Paris as a timely – indeed compelling – subject for painting. But Caillebotte's style was entirely his own, his brush strokes smaller and tighter, his palette less colorful, the city he portrayed often more complex.

In one canvas, the roofs of both the adjoining train station and the new Opéra, several

The pont de l'Europe, opened in 1868, replaced a pair of old stone tunnels that could no longer handle the increased traffic around the enlarged Gare Saint-Lazare.

During street fighting with government forces, rebel Communards tried to find cover behind the stone pillars that support the pont de l'Europe.

Caillebotte's *Floorscrapers* (*Les Raboteurs des Parquet*) can be seen at the Musée d'Orsay.

A. Lamy, *The Pont de l'Europe and the Gare Saint-Lazare*, 1868. The New York Public Library

G. Caillebotte

blocks away, are barely visible through the heavy iron girders that supported the bridge until it was remodeled in 1930. In the other, Caillebotte, like Manet, presents an ambiguous slice of modern Parisian life. A gentleman stroller, generally thought to be a self-portrait of the twenty-eight-year-old artist, takes interest in a fashionable woman, who may or may not be a prostitute from one of the many brothels that were a feature of the area near the depot. Looking through the bars at the activity on the tracks below is an *ouvrier*, one of the laborers whose hard work had created neighborhoods such as this in the preceding twenty years.

Whereas Renoir and Monet had each contrasted the historic and modern parts of town a decade earlier, Caillebotte – the youngest of the group, who was only five when Haussmann began to dismantle the old city – shows only the new. This is a Paris dominated by commerce and industry, composed entirely of steel and masonry. Everything about this painting communicates the sense of disquiet that some now felt in the city – the steeply pitched perspective of the rue de Vienne as it approaches the central *place*, the enormous, looming girders, the harsh, bleached-out light, the absence of any greenery, the lack of connection among the assembled characters.

Walk around to rue de Londres to face the rue de Vienne through the fence.

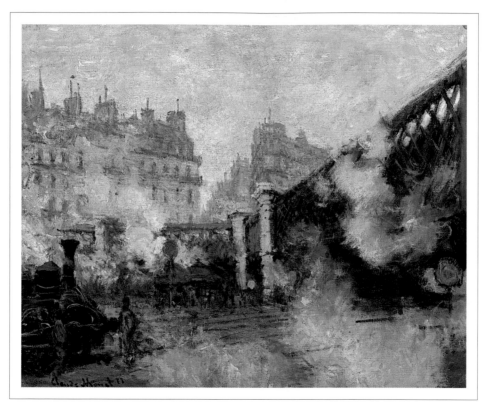

Monet: *The Pont de l'Europe*, 1877. Paris, Musée Marmottan

Gare Saint-Lazare, site of Monet's train station series, 1877

Monet also began to work in the area around the station in the following year, the first of the group, however, to actually represent the trains. Ignoring the psychological component of Manet's and Caillebotte's paintings, Monet was intrigued by the raw power of the engines and the fanciful effects of sunlight on smoke and steam, a scene somewhat less poetic today, as Monet's soft, billowing clouds have been replaced by networks of unsightly electrical cables.

Renoir later recalled that his friend had put on his best clothes and presented himself to the station director as the famous artist Claude Monet. The falsely impressed official had the trains stopped and the engines filled with coal to accommodate the painter, who perhaps identifying more with the railway workers than his aristocratic associates had, set up his easel right beside the tracks that had so fascinated the figures in his friends' slightly earlier works.

The Gare Saint-Lazare, the largest rail depot in Paris, had special meaning for Monet. It was the station from which he departed for his native Normandy as well as for the western suburbs of Bougival, Argenteuil, and Pontoise that he and the other Impressionists were so fond of painting. And, as it still is today, it was the place to catch the train to his final home in Giverny.

Monet executed twelve pictures here over the next few months, painting either inside the

Giverny

Monet spent the last four decades of his life here, planting and then painting the famous water lily garden. Forty miles northwest of Paris, Giverny can be reached by the Rouen line from the Gare Saint-Lazare to Vernon and then by taxi to the house.
02.32.51.28.21
APR-OCT: TU-FRI 10AM-NOON, 2-4PM;
SAT-SUN 10AM-6PM;
GARDENS DAILY 10AM-6PM

MUSÉE MARMOTTAN
2, RUE LOUIS-BOILLY
01.42.24.07.02
TU-SUN: 10AM-5:30PM
MÉTRO: LA MUETTE
TUCKED AWAY IN THE QUIET 16TH ARRONDISSE-MENT, THE MARMOTTAN RECEIVED THE BEQUEST OF MONET'S ART COLLECTION – INCLUDING HIS OWN *PONT DE L'EUROPE* AND CAILLEBOTTE'S *STUDY FOR PARIS STREET; RAINY DAY* – WHEN THE ARTIST'S SON MICHEL DIED IN 1966.

m MOLLARD
115, RUE SAINT-LAZARE
01.43.87.50.22
DAILY TILL 1AM
MÉTRO: SAINT-LAZARE.
In business since 1867, this brasserie, an historic monument, boasts faience murals depicting the towns reached by the Gare Saint-Lazare across the street.

On June 28, 1870, Monet married his mistress, Camille Doncieux, at the mairie, *the town hall, of the 8th arrondissement on the nearby boulevard Malesherbes. The painter Gustave Courbet was a witness.*

11 CAFÉ TERMINUS LAZARE
108, RUE SAINT-LAZARE
01.40.08.43.30
DAILY NOON-2:30PM, 7-10:30PM
MÉTRO: SAINT-LAZARE
Gustave Eiffel designed this hotel and its café in 1889, the same year as his famous tower.

glass-roofed train shed (one picture is in the Musée d'Orsay) or on the platforms just beneath the pont de l'Europe (one is in the Musée Marmottan). Three works in the series once belonged to Caillebotte, who subsidized the ever-impoverished Monet in a ground-floor studio just to the east at 17, rue de Moncey (H). This benefactor would later also pay the rent for a large apartment a few blocks west of the station at 26, rue d'Édimbourg (I), where Monet's son Michel was born, and once again in a studio nearby at 20, rue Vintimille (J), the neighborhood – close to both the depot and the Impressionists' favorite cafés – suiting Monet perfectly for his Parisian *pieds-à-terre*.

Monet, who soon settled permanently in Giverny, happily declaring himself "a countryman again," would paint the streets of the capital for the last time in 1878, returning to the city from then on only in order to sell his pictures.

> **Take the rue de Liège one block, crossing and turning up the rue de Turin,
> stopping just short of the next corner, the place de Dublin.**

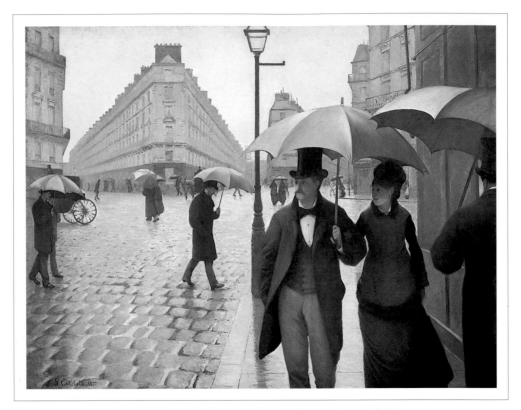
Caillebotte: *Paris Street; Rainy Day*, 1877. The Art Institute of Chicago

STOP 8 Place de Dublin, site of Caillebotte's *Paris Street; Rainy Day,* 1877

The year after working on the pont de l'Europe, Caillebotte turned his attention to one of the streets that radiates off it in his best-known painting, *Paris Street; Rainy Day.* The artist's descendants recalled that he worked from the shelter of a carriage to prepare this somber gray-toned view of the rue de Saint-Petersbourg as it becomes part of the typically Haussmannian, eight-street intersection known as the place de Dublin. Today, even in a residential neighborhood such as this, it is impossible to recreate the haunting sense of calm in the scene, where the figures crossing through the slick cobblestone streets have been likened to sleepwalkers. But this stillness so evocative of a dream was probably an exaggeration in 1877. By comparing the actual site with the background as it appears in the painting, we can see how here again Caillebotte manipulated the space before him. He contrives a starker intersection of long straight streets of identical buildings, evoking the banal uniformity of life in the impersonal modern city. Even the title, *Paris Street*, instead of *Rue de Turin*, warns of the sameness that seemed to threaten so much of the capital.

Caillebotte showed both quartier de l'Europe cityscapes at the Impressionist exhibition that year and paid the rent for the premises on the rue Le Peletier. One reviewer, mocking the group's

WHEN CAILLEBOTTE'S COLLECTION WAS BEQUEATHED TO THE STATE FOLLOWING HIS DEATH IN 1894, THE CONSERVATIVE STAFF AT THE ACADÉMIE DES BEAUX-ARTS THREATENED TO RESIGN. AFTER YEARS OF HAGGLING, THE ACCEPTED WORKS WERE FINALLY INSTALLED, THOUGH DENOUNCED IN THE SENATE AS AN INSULT TO FRANCE.

The names of streets in the quartier de l'Europe are an ever-changing reflection of politics. The rue de Saint-Petersbourg was changed to rue de Leningrad and then back again, echoing the historic upheavals in that city. The rue de Berlin became the rue de Liège during the First World War.

Note that as in Caillebotte's painting, a pharmacy still occupies the triangular-shaped shop on the ground floor of the building at the junction of the rue de Moscou and the rue Clapeyron. A reproduction of Paris Street; Rainy Day is displayed behind the counter.

o LE PRIMEROSE
11 BIS, RUE DE MOSCOU
01.43.87.53.50
MON-FRI 6:30AM-9:30PM
MÉTRO: LIÈGE
The terrace of this simple café is ideally situated for contemplating the site of Caillebotte's melancholy street scene at leisure.

name and the fact that the figures in *Paris Street; Rainy Day* continue to carry their open umbrellas even though the weather appears to have cleared, quipped that "the rain seems to have made no *impression* on Monsieur Caillebotte."

The generous artist gave a more impressionistic study for *Paris Street; Rainy Day* (now in the Musée Marmottan) to Monet, who displayed it for years in his bedroom at Giverny.

Turn left onto the rue de Saint-Petersbourg, continuing half a block to N° 4, opposite the rue de Berne.

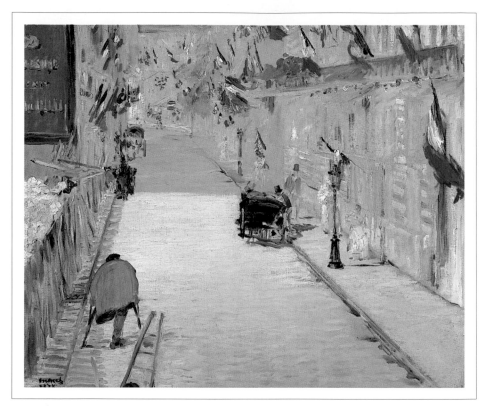

Manet: *Rue Mosnier Decorated with Flags*, 1878. Los Angeles, The J. Paul Getty Museum

STOP 9 Nº 4, rue de Saint-Petersbourg, site of Manet's rue Mosnier paintings, 1878

During the following year, Manet painted three pictures of the unfinished rue Mosnier (renamed rue de Berne in 1884) from the second-floor window of his elegant studio, a former fencing school, at 4, rue de Saint-Petersbourg, where visitors noted that the floor continually trembled from the trains entering and leaving the nearby station. Shortly before moving out, the artist captured pavers completing their job in the street that soon would be described by his friend Émile Zola in *Nana* as a place where prostitutes had set up shop.

The other two canvases commemorate the Fête de la Paix, a national holiday on June 30th that year. Each of these shows the street festooned with the French tricolor flying from every window, which might seem like an overt sign of patriotism were it not for Manet's inclusion of a one-legged workman in the foreground of one — a powerful juxtaposition of nationalism and its sometimes bloody consequences. In fact, the rue Mosnier had been the scene of intense fighting during the Commune in 1871, a time when Manet sketched corpses nearby on the boulevard Malesherbes.

The crippled man is a sad and curious omen, as Manet's own left leg would be amputated shortly before his death in just five years.

Head up the rue de Saint-Petersbourg, taking note of Nº 39 (K), where Manet died in 1883, to the place de Clichy (move to Map 4 on page 72). Cross the *place* to the avenue de Clichy to Nº 9, opposite the passage Lathuile.

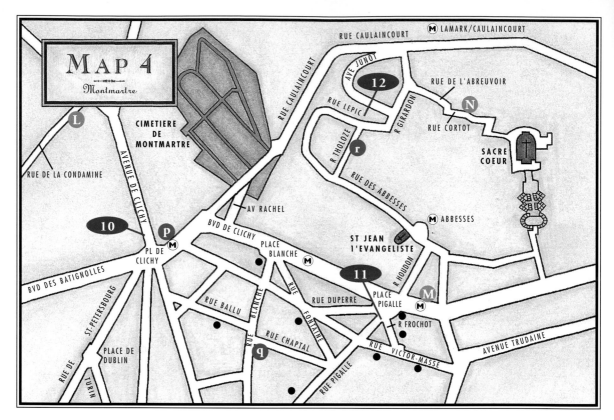

MAP 4
Montmartre

L

RUE CAULAINCOURT

Ⓜ LAMARK/CAULAINCOURT

CIMETIERE
DE
MONTMARTRE

RUE CAULAINCOURT

AVE JUNOT

12

RUE DE L'ABREUVOIR

RUE LEPIC

R GIRARDON

N

RUE CORTOT

RUE DE LA CONDAMINE

AVENUE DE CLICHY

R. THOLOZE

r

SACRE
COEUR

RUE DES ABBESSES

AV RACHEL

10

BVD DE CLICHY

Ⓜ ABBESSES

P
Ⓜ

PL DE
CLICHY

PLACE
BLANCHE

ST JEAN
l'EVANGELISTE

Ⓜ

BVD DES BATIGNOLLES

RUE

BLANCHE

RUE

11

R HOUDON

ST-PETERSBOURG

RUE BALLU

RUE DUPERRE

PLACE
PIGALLE

Ⓜ
Ⓜ

RUE DE

FONTAINE

R FROCHOT

TURIN

PLACE DE
DUBLIN

RUE

RUE CHAPTAL

q

RUE

VICTOR-MASSE

AVENUE TRUDAINE

RUE PIGALLE

LEGEND

STOP 10 Site of the Café Guerbois ~ 9, avenue de Clichy

STOP 11 Site of the Café de la Nouvelle-Athènes ~ place Pigalle

STOP 12 Site of the Moulin de la Galette ~ 79, rue Lepic

L Studio of Frédéric Bazille ~ 9, rue de la Condamine

M Final residence of Edgar Degas ~ 6, boulevard de Clichy

N Studio of Auguste Renoir ~ 12, rue Cortot

p Wepler ~ 14, place de Clichy

q Baggi ~ 33, rue Chaptal

r La Galerie ~ 16, rue Tholozé

● Additional Sites

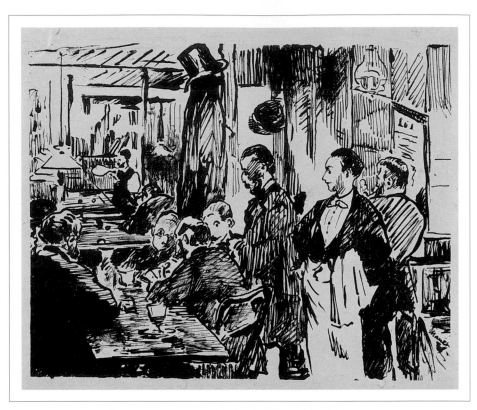

Manet: *At the Café*, 1869. National Gallery of Art, Washington

STOP 10 N°9, avenue de Clichy, site of the Café Guerbois and
Manet's *At the Café*, 1869

No institution is more closely associated with Paris than its cafés and no style of French paint-ing is more suggestive of those cafés than Impressionism. There had been plenty of cafés in the years before Haussmann, but the wide sidewalks on his new boulevards made people-watching from café terraces a new national pastime. For artists who spent long hours alone in the studio, the cafés were a welcome nightly escape once the fall of darkness cut short the workday. For the

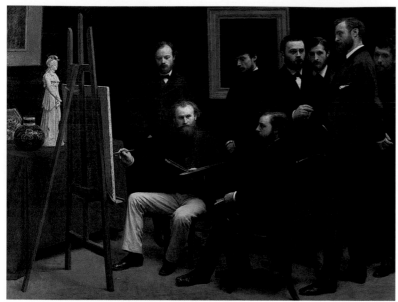

Henri Fantin-Latour: *Studio in the Batignolles*, 1870. Paris, Musée d'Orsay
Painted the same year as Bazille's more informal studio scene (page 4), Fantin-Latour's *homage* to Manet depicts the leader of the young avant-garde artists and their supporters at his easel working on a portrait of the poet Zacharie Astruc. Standing behind them are, left to right, the German artist Otto Scholderer, Renoir, Zola, the musician Edmond Maître, Bazille, and Monet.

\mathcal{B}azille captured the atmosphere of his large Batignolles *atelier* at N° 9 rue de la Condamine in a canvas (page 4) that includes portraits of Zola on the steps chatting with Renoir, who shared the studio and whose nude is propped up beside the window; Monet, smoking, and Manet examining a picture on the easel; Bazille, whose likeness was added by Manet, holding a palette; and the musician Edmond Maître playing the piano.

**WEPLER, 14, PLACE DE CLICHY
01.45.22.53.24. DAILY TILL 1AM
MÉTRO: PLACE DE CLICHY
CONSIDERED THE PLACE FOR OYSTERS
IN PARIS**

Impressionists, who worked with little recognition, the camaraderie of these evening *rendez-vous* helped fortify their resolve to return the next morning to the canvases on their easels. Their café of choice in the mid to late 1860s was the Café Guerbois at 9, grande rue des Batignolles (today avenue de Clichy), just off the place de Clichy. The extroverted Manet was the undeniable center. He invited the outspoken Monet, who then brought the shy and nervous Renoir, who, lacking the temperament and formal education, did not play a major role in the often heated aesthetic debates. Degas, sarcastic and intimidating, came often but never stayed very long. Also in attendance were Émile Zola, who included a description of the Guerbois group in his novel *L'Oeuvre*, and Bazille and Fantin-Latour, who, in 1870, would both paint group portraits of the café regulars. Provincials, such as Cézanne and Pissarro, stopped by when they were in town. It was at the marble-topped tables set in the elegant white-and-gold interior here that plans were hatched for the first independent exhibition of 1874. Despite the number of artists the café attracted, the only known picture of the Guerbois is, appropriately, by Manet, who focused on that quintessential Parisian character the café waiter. As they got older, the Impressionists switched their allegiance to the quieter Café de la Nouvelle-Athènes on the nearby place Pigalle.

Walk east along the boulevard de Clichy (detouring up the avenue Rachel to the Montmartre Cemetery to visit Degas' grave if you wish) to the place Pigalle. Or take the Métro, Line 2 (Direction: Nation), two stops to Pigalle.

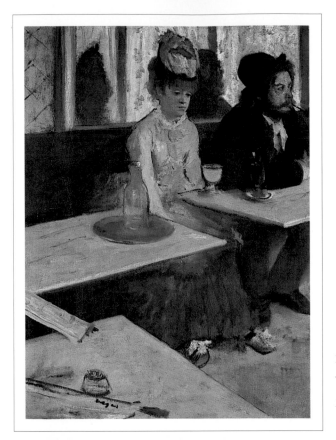

Degas:
Absinthe,
1876. Paris,
Musée d'Orsay

G. C. A., Paris 794 Montmartre. — La rue Pigalle — Nouvelle Athènes.

STOP 11 **Place Pigalle between rue Frochot and rue Pigalle, site of the Café de la Nouvelle-Athènes and Degas' *Absinthe*, 1876**

Mondays, the place Pigalle, at the foot of the *butte* Montmartre, was the site of the market for artists' models, who on other days would gather in the cafés around the *place*, the Nouvelle-Athènes being the one the Impressionists called their headquarters in the 1870s. This was Degas' territory – he was born at 8, rue Saint-Georges (no longer standing), and later lived or kept studios at eight locations all within a quarter mile of the place Pigalle. And it was Degas who captured the Nouvelle-Athènes (in the building that now houses a theater) in one of his best-known paintings,

*In 1912, Degas at the age of 78 was forced to leave his home at 37, rue Victor-Massé. The model and painter Suzanne Valadon found a new combination studio and apartment nearby on the boulevard de Clichy (*right*) for her elderly friend and mentor, who, as a lifelong bachelor, had no children to look after him. Degas lived here at № 6* *until his death five years later. It is easy to imagine the old painter, stooped, frail, nearly blind, making his way home through the place Pigalle at the corner, passing the site of the Café de la Nouvelle-Athènes, where he and the other young rebels had gathered four decades earlier, passionately debating theories that would change the history of art forever. Bazille had been gone for more than 40 years, Manet for 30, Caillebotte for nearly 20. Monet was ensconced in his house in Giverny, Renoir retired to the South of France.*

Degas had outlived the major Post-Impressionists – van Gogh, Gauguin, Toulouse-Lautrec, and Cézanne – Matisse's Fauvist outrages were over a decade old, Picasso and Braque had already created an art they called Cubism. When this well-traveled man of the world died here on September 27, 1917, he was just eight blocks from his birthplace on the rue Saint-Georges. He was then buried in the Montmartre Cemetery another six blocks away. Most 19th-century Frenchmen died in the same towns or villages where they were born. Degas was no different. But Degas' town was Paris and his village was Pigalle.

in 1876. The café sitters were the engraver Marcellin Desboutin, who may appear in acknowledgment of his role in initiating the group move here from the noisier Café Guerbois. The woman was the actress Ellen Andrée, who also posed for Manet and Renoir. The pale light reflected in the mirror behind the pair tells us it is morning. And the drink the man has before him was a popular hangover remedy, a *mazagran*, cold black coffee and seltzer water. Her glass holds the infamous *absinthe*, a highly addictive potion concocted from wormwood, hyssop, mint, and anise, its distinctive pale green color the giveaway.

As Caillebotte was doing that same year on the streets of the nearby place de l'Europe and place de Dublin, Degas has manipulated the interior space of the Nouvelle-Athènes and therefore the viewer's experience of it. The aggressive diagonals of the marble-topped café tables, which, seemingly legless, appear to float, contribute to the general feeling of unease and inebriation. And, despite the fact that years later Andrée complained that Degas had made her and Desboutin look like idiots, it is her slumped shoulders and vacant expression of utter hopelessness that have given this painting its enduring power.

When the Irish writer George Moore arrived in Paris in 1872, he joined the circle of artists and poets that met at the Nouvelle-Athènes, dubbing it "the real French Academy." He reveled

In 1866, Monet rented a small fourth-floor studio at 1, place Pigalle. A young woman from the neighborhood, Camille Doncieux, became his model, his mistress, and, several years after the birth of their first son, his wife.

THE PLACE PIGALLE, TODAY THE CENTER OF PORNOGRAPHIC PARIS, IS NAMED FOR JEAN-BAPTISTE PIGALLE, A 19TH-CENTURY PAINTER AND SCULPTOR NOTED FOR HIS IMAGES OF THE VIRGIN MARY.

q **BAGGI**
33, RUE CHAPTAL
01.48.74.01.39
TU-SAT: 10:30AM-7:15PM
(CLOSED SUN AND MON)
MÉTRO: PIGALLE
This small, simple restaurant and ice cream parlor has been in business since the 1850s, when Manet attended art school on the nearby rue de Laval (today rue Victor-Massé).

The wealthy American expatriate Mary Cassatt passed the Nouvelle-Athènes daily on her way from her studio around the corner at 2, rue Duperré to her home at 13, avenue Trudaine. Unlike female models such as Victorine Meurent and Ellen Andrée, bourgeois ladies such as Cassatt or Berthe Morisot could not join the male painters when they gathered at cafés.

SAINT-JEAN-L'ÉVANGÉLISTE 19, RUE DES ABBESSES
Degas' funeral was held here, a block north of his home on the boulevard de Clichy. The Art Nouveau church (1890-1904), the first built with reinforced concrete, was dubbed Saint-Jean-des-Briques in honor of its unusual brick facing.

in the various scents of the café throughout the day: in the morning, "eggs frizzling in butter"; in the late afternoon, "the fragrant odor of absinthe"; and through the evening, "the mingled smells of cigarettes, coffee and weak beer."

Cross the boulevard de Clichy, turning up the rue Houdon. Turn left onto the rue des Abbesses, passing the church of Saint-Jean-l'Évangéliste, where Degas' funeral service was held. Continue toward the rue Tholozé, climbing up to the rue Lepic.

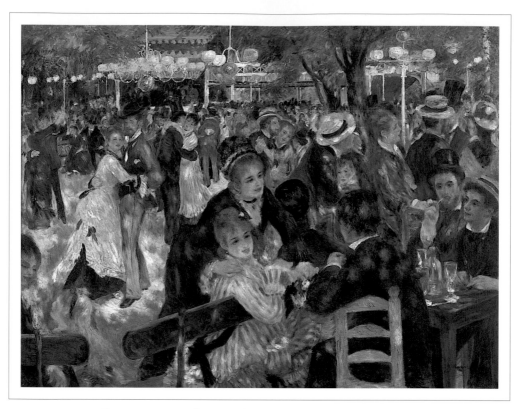

Renoir: *Dancing at the Moulin de la Galette*, 1876. Paris, Musée d'Orsay

STOP 12 N° 79, rue Lepic, site of Renoir's
Dancing at the Moulin de la Galette, 1876

In the same year that the sardonic Degas immortalized the dissipated side of café life down the hill on the place Pigalle, Renoir, true to his cheerful disposition, painted the joyous whirl of the popular outdoor dance hall in *Dancing at the Moulin de la Galette*. Located on the western peak of

The Sacré Coeur, built in gratitude for deliverance from the horrors of the Franco-Prussian War, was in the first stages of its long construction in 1876 while Renoir worked nearby at the Moulin de la Galette.

r LA GALERIE
16, RUE THOLOZÉ
01.42.59.25.76. OPEN
UNTIL 10:45PM (CLOSED
SUN). MÉTRO: ABBESSES
Tiny restaurant/art gallery

The Moulin de la Galette was painted in the 1880s by Toulouse-Lautrec and van Gogh and at the turn of the century by Picasso.

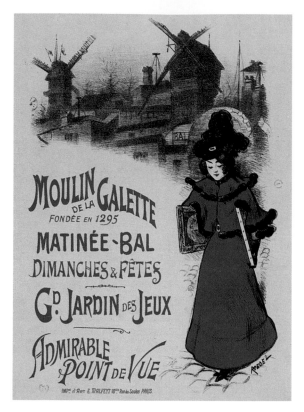

N MUSÉE MONTMARTRE
12, RUE CORTOT
01.46.06.61.11
TU-SAT 2:30-6PM; SUN 11AM-6PM (CLOSED MON)
MÉTRO: LAMARK-CAULAINCOURT
Renoir rented the courtyard building – today a museum devoted to the history of Montmartre – for its proximity to the dance hall. He painted *The Swing* (Musée d'Orsay) in the garden here.

Montmartre at the foot of a windmill (*moulin*), this was a place where respectable working-class families, students, and artists gathered on Sunday to waltz, drink wine, and eat griddle cakes (*galettes*) made from the grain milled there. Keeping his main *atelier* at 35, rue Saint-Georges, Renoir rented another studio at 12, rue Cortot – today the Musée Montmartre (N) – specifically for this project. Past vineyards and dairy farms, he carried the enormous canvas back and forth to the dance hall for six months, soaking up the atmosphere and getting to know the regulars, creating what many believe is his masterpiece. Renoir's renown as the most innovative colorist among the Impressionists is nowhere more apparent than in this work, which a reviewer at the time applauded as being "like the shimmer of a rainbow."

Caillebotte bought the work to help Renoir, who asked for it back twenty years later when he served as executor of his benefactor's estate. The Caillebotte family refused, and today the painting is a centerpiece of the Impressionist works he donated to the state that are now displayed at the Musée d'Orsay.

> **Note: The next stop on the tour, the Folies-Bergère on the rue Richer in the 9th arrondissement (see Map 2 on page 38), is not easily accessible from this location. If you wish to visit it, take the Métro to either Cadet (Line 7) or Rue Montmartre (Line 9).**

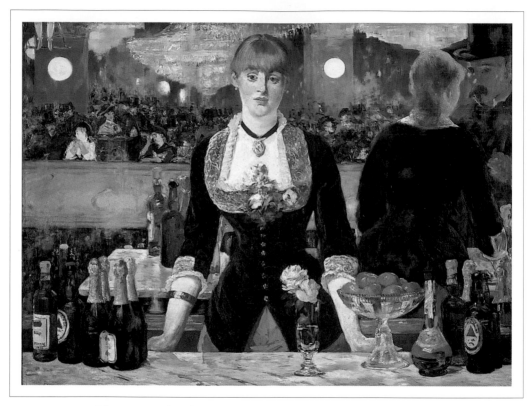

Manet: *Bar at the Folies-Bergère*, 1882. London, Courtauld Institute Galleries

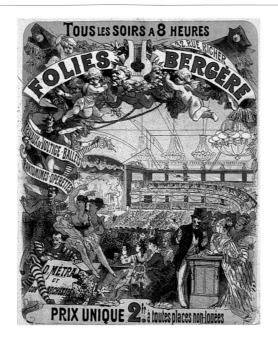

STOP 13 N° 32, rue Richer, the Folies-Bergère, site of Manet's painting of the cabaret, 1882. Métro: Cadet or Rue Montmartre

BEATAE MARIAE VIRGINI LAURETANAE

NOTRE DAME DE LORETTE
18, RUE CHATEAUDUN

In 1832, Degas' parents were married in the church that gave its name to the prostitutes, *les lorettes*, who frequented the area – an omen for the many brothel scenes their son would go on to paint. In 1840, the newborn Claude Monet was christened here, across the street from his birthplace at 45, rue Lafitte. Caillebotte's funeral service was held at the same church in 1894.

k CHARTIER
7, RUE DU FAUBOURG-MONTMARTRE
01.47.70.86.29
11AM-3PM, 6:00-9:30PM.
MÉTRO: RUE MONTMARTRE

The hundred-year-old Chartier offers bargain-priced cuisine in an enormous, landmarked interior.

THÉÂTRE DES VARIÉTÉS
7, BD. MONTMARTRE

IN 1877 *LE CIGALLE* (*THE CICADA*), A COMEDY THAT SATIRIZED THE IMPRESSIONISTS – CALLED "INTENTIONISTS" – OPENED AT THIS THEATER. DEGAS, A FRIEND OF THE AUTHORS, HELPED WRITE MANY OF THE FUNNIEST GAGS.

l AU PETIT RICHE
25, RUE LE PELETIER
01.47.70.68.68
NOON-2:30PM, 7PM-MID-NIGHT. (CLOSED SUN)
MÉTRO: RICHELIEU/DROUOT

Open since 1854, Au Petit Riche was across the street from the old Opéra, where Degas first painted his ballerina pictures.

During the Prussian siege of Paris in 1870, the Folies-Bergère was one of several theaters used for patriotic rallies. Manet and Degas attended a lecture on the use of firearms here.

The facade of this famed Parisian night spot reflects the 1929 redecoration of Josephine Baker's era rather than the style of Édouard Manet's more than 40 years earlier. Unlike Renoir's rustic family dance parlor at the Moulin de la Galette, the Folies-Bergère, opened in 1869, was a chic, sophisticated cabaret where well-to-do Parisians like Manet enjoyed circuses, vaudeville acts, operettas, and dance troupes. As Jules Chéret had done in his 1875 poster, (page 89), Manet's painting focuses on a server at one of the three bars, leaving the theatrical spectacle as a background element – a trapezist's feet are visible at the upper left. Contemporary guidebooks warned tourists of the Folies' racy reputation, and the women who worked there were generally assumed to sideline as prostitutes. Manet, however, makes no judgment. He gives the bartender – a real employee there named Suzon posed for the central figure – a dignified, if resigned, expression as she is approached by a man visible only in the ambiguous reflection behind her.

Bar at the Folies-Bergère was Manet's last major work before his death the following year, and it is a tour-de-force summation of the theme that most intrigued the painter during his brief 25-year career – the outwardly sparkling city where things were not always as they seemed.

GRAVE OF ÉDOUARD MANET
Passy Cemetery
2, rue du Commandant-Schloesing
Métro: Trocadéro

GRAVE OF GUSTAVE CAILLEBOTTE
Père-Lachaise Cemetery, Division 70
Boulevard du Ménilmontant
Métro: Père-Lachaise

GRAVE OF EDGAR DEGAS
Montmartre Cemetery, Division 4
Avenue Rachel
Métro: Place de Clichy

I t's no surprise that the most Parisian of the Impressionists – Caillebotte, Degas, and Manet, who once remarked that it was impossible to live anywhere else – are still Parisians, each buried in one of the city's cemeteries. Monet, though born in the capital, spent his childhood in Normandy and is interred where he died, at his home in Giverny. Renoir, who was born in Limoges, is buried in Cagnes-sur-Mer in the South of France.

On April 30, 1883, Manet died in his apartment at 39, rue de Saint-Petersbourg. A funeral at Saint-Louis d'Antin, near the Gare Saint-Lazare, with Monet, Fantin-Latour and Zola among the pallbearers, was followed by a procession to Passy Cemetery. The artist was buried in a plot purchased by his brother Eugène and Eugène's wife, the painter Berthe Morisot, who (along with Édouard's wife, Suzanne) were eventually interred here as well. Both Manet and Morisot had painted views of the city from the nearby Trocadéro hill.

Though he lived most of his life in the center of Haussmann's new Paris, Caillebotte's pictures are among the strongest indictments of the unsettling uniformity of that city. In death, Caillebotte ironically shares the Père-Lachaise Cemetery with Baron Haussmann. Among the many other artists buried here are fellow Impressionist Camille Pissarro and that great photographic chronicler of the age, Nadar (Félix Tournachon), who lent his studio rent-free for the first Impressionist exhibition. In the southeastern corner, the Mur des Fédérés (The Federalists' Wall) commemorates the spot where 147 cornered Communards were executed without trial and buried in a mass grave where they fell.

Degas is now entombed just a mile north of his birthplace on the rue Saint-Georges. The family crypt, which bears the more noble spelling of the surname that some of his relatives favored, is adorned with the portrait of the artist, who reportedly evicted a distant cousin to make room there for himself.

AFTERWORD

Just as Manet had originally brought them together, his death in 1883 contributed to the ultimate breakup of the Impressionist group. Now entering middle age, and free of many of the woes that had bound them together before their art became widely accepted and profitable, the remaining artists abandoned Paris as a major subject, each turning his attention elsewhere to pursue individual creative aims.

Caillebotte retreated from the limelight he had known as part of the leading avant-garde artistic movement of its day, occasionally painting the area around the suburban home he shared with his mistress until his death at 45 in 1894. Degas focused on working women – ballerinas, singers, laundresses, prostitutes – ending his 60-year career shortly before the First World War. Renoir exchanged his Impressionist vocabulary for a more classical style, devoting himself primarily to painting the female nude until his death in 1919 at the age of 78. Monet, always a landscapist at heart, gave up the city in favor of the glories of the French countryside – creating his great series of haystacks, poplars, and finally water lilies – living the longest of all the group, to age 86 in 1926.

In fact, the only original member of the Impressionist circle to paint the city after the 1880s was Camille Pissarro (1830-1903), who previously had shown no interest in the subject. In

the last decade of the century, however, Pissarro began a series of views of the *grands boulevards*, which by then had become fixtures of the cityscape, part of the Paris that today we accept as always having been there but that was once so startlingly new that, for a brief time, it captured the collective imagination of a generation of artists and inspired some of the world's most beloved paintings.

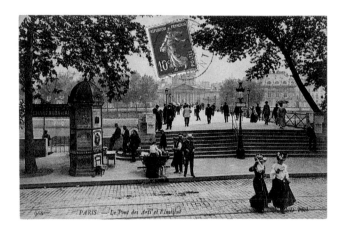

List of Illustrations

NOTES

Ellen Williams is also the author of *Picasso's Paris* (The Little Bookroom). She is the former art editor of *Vogue* and executive editor of *The Journal of Art* and attended the Institute of Fine Arts, New York University. She edited Alexander Liberman's *The Artist In His Studio* (Random House) and *Keith Haring Journals* (Viking) and has written about Paris for *Travel & Leisure*, *International Design Magazine*, *Allure*, and other publications. She is now at work on a book about 19th-century restaurants and gourmet shops still in business in Paris today. She lives in New York City with her daughter.